DOGS
ON INSTAGRAM

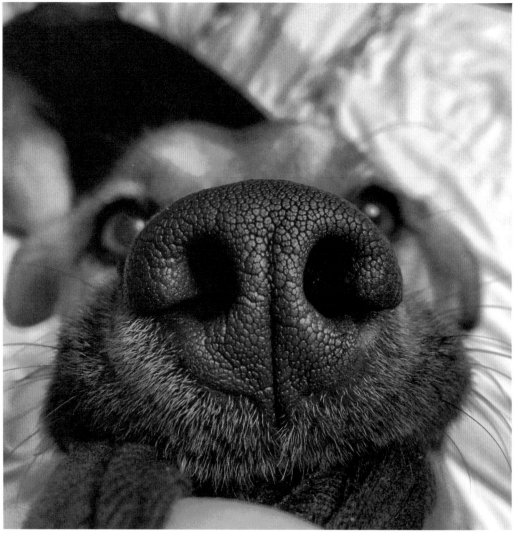

DOGS
ON INSTAGRAM

by @dogsofinstagram

CHRONICLE BOOKS

San Francisco

Introduction and Compilation Copyright © 2016 by DOI LLC.

Dogs on Instagram and @dogsofinstagram are operated independently and are not affiliated with, endorsed, or sponsored by Instagram LLC. All photographs copyright © by the individual photographers.

Library of Congress Cataloging-in-Publication Data available.

ISBN 978-1-4521-5197-7

Manufactured in China

Design by **Alissa Faden**

Front jacket photographs by: @smalls.the.corgi, @missflipflops, @Jeanie3legs, @crazyaboutspots, @mydogarthur, @ellabeanthedog, @lunablueheeler, @scvitkovic1, @Pigzilla, @thepawsome3, @blakewilbo, @Diesel_the_frenchie, @loki_the_wolfdog, @iheartwallace

Back jacket photographs by: @willa_thepup, @Junior_the_copenhagen_lab, @domcarson, @little.sawyer, @rafa3lla, @deanthebasset, @buksnort, @agirlandheraussie, @Corgi_Aussie, @noodlethedachshund

Front flap photographs by: @igstagrams, @bonjour_manoush, @toriasauras, @thetrickdog

10 9 8 7 6 5 4 3 2 1

Chronicle Books LLC
680 Second Street
San Francisco, CA 94107
www.chroniclebooks.com

DEDICATION

For our beloved Lucy, who inspired it all.
You make our tails wag each and every day.

INTRODUCTION

When we started @dogsofinstagram in July 2011, the concept was simple: bring together the dogs of Instagram in an easy to find place and deliver daily doses of doggy cuteness. The idea was twofold. People could rely on one social media account to deliver the best dog photos and stories around. Perhaps more importantly, Followers of this account could contribute their personal best photography, created with their own beloved pets.

Dogs have always had a place in our homes and hearts. So, it is only natural that they found a place in our Instagram feeds. Since launching our Instagram account, we have amassed millions of dog-loving Followers. The grand majority of our photo content is submitted via email by our followers and we have received tens of thousands of photos to our inbox. These photos have come from hundreds of countries around the world. This is a testament to the universality of dogs and how we, as humans, treasure the relationships we have with our pups.

We know what you're thinking and the answer is "yes." Yes, we look at every single submission. We distill the hundreds of daily submissions down to three to five of the most inspiring photos that we share with our Followers each day. So, how do we pick? We work hard to showcase the diversity of dogs across shapes and sizes, breeds, mixes, ages and abilities. We attach our name to causes we believe in. We select expressions that make us laugh out loud and stories that melt our hearts. Above all, we strive to provide fresh and entertaining photos for dog lovers worldwide, pushing ourselves to share better content each and every day!

Curating the images showcased in this book has been such a joyful process, allowing us to reflect back on our most popular posts, lovable faces, and @dogsofinstagram milestones. This book serves as a celebration of a community five years in the making. As you peruse this book, we invite you to experience some of our favorite photos in a completely new way! A tactile, page-turning, good time where you don't have to scroll, but can let your eyes leisurely take in the beauty of man's best friend. We bet you'll finding yourself trying to "double tap" the photos that make you smile!

Enjoy the cuteness,

Ahmed and Ashley,
the humans behind @dogsofinstagram

@amandayiwong

@lil.sawyer

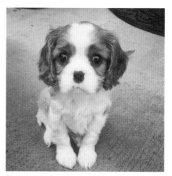

@dempseymcpuppy

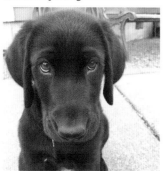

@kk.j___

"Happiness is a puppy."

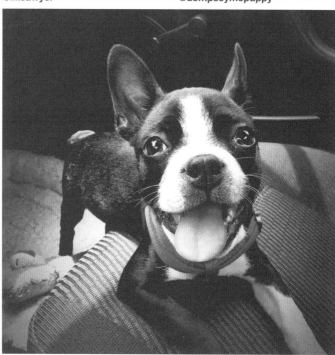

@joonyaboy

@amandalee_f

@koa_mila

@waldokimthecorgi

@thegoldenfinn

@Reagandoodle

@voguehuskies

@DobermanDuo

@patwerkstump

@clari_calahari

@goldens.unleashed

@eu_jeremias

@teddythepoodlebear

@homercucul

@codythehuskypup

"I love to run on the beach but I hate getting my paws wet!"

@japaolin

@Emme_the_golden

@Kyra.bc

@davidfongs

@lifeofjinkee

@jyebolton

@iamthealmightygoliath

@megonearth

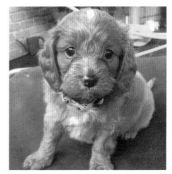

@popcorn_the_pup

@poohbearthegoldie

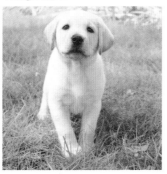

@winnielabrador

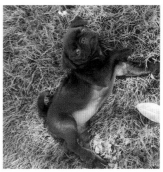

@TheOfficialMotive

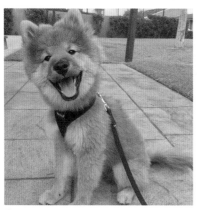

@ras_carter_pham

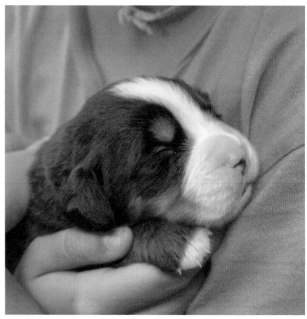

@brynnthebernese

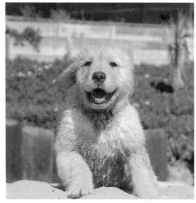

@berkeleythegoldengirl

"When you wake up and realize it's a Friday."

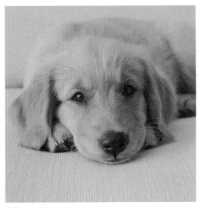

@Rachhildebrat

@rambo_thecorgi

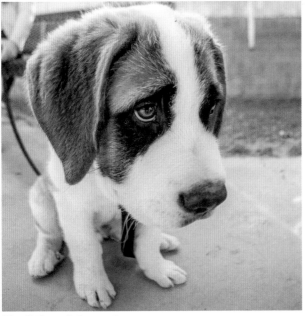

@benji_the_saintbernard

@thebrucetails

@molohmeier

@buzzthesquishypug

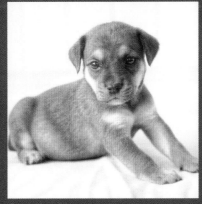

@artisticvoid

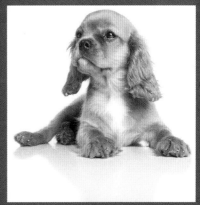

@markbinks

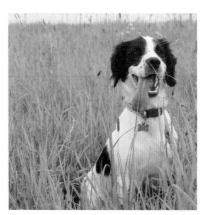

@sarahlouisehh1992

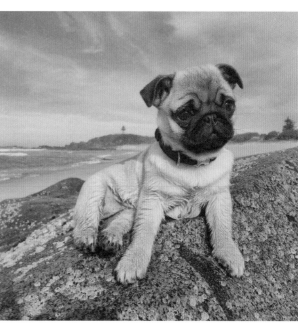

@LunaDelPug

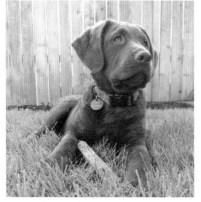

@jurassica_marie

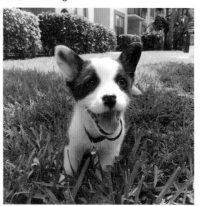

@BAAMMBBIII

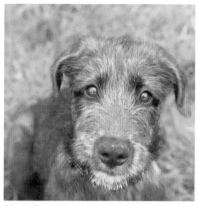

@izziethewolfhound

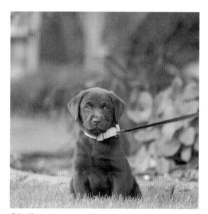

@imijry

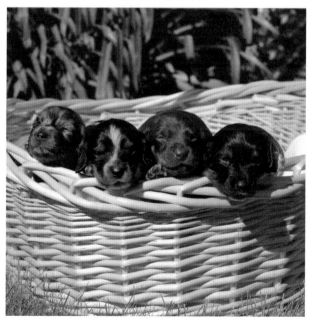

@thedoxieteers

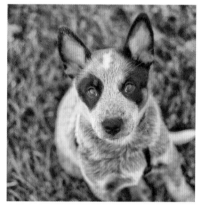

@smrphotography87

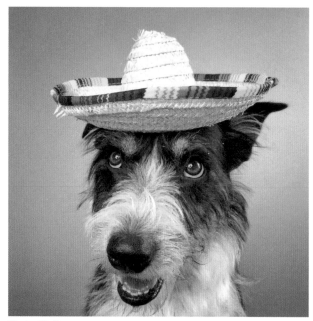

@missflipflops

@maverick_poser

"Let's have a serious talk about not taking yourself so seriously."

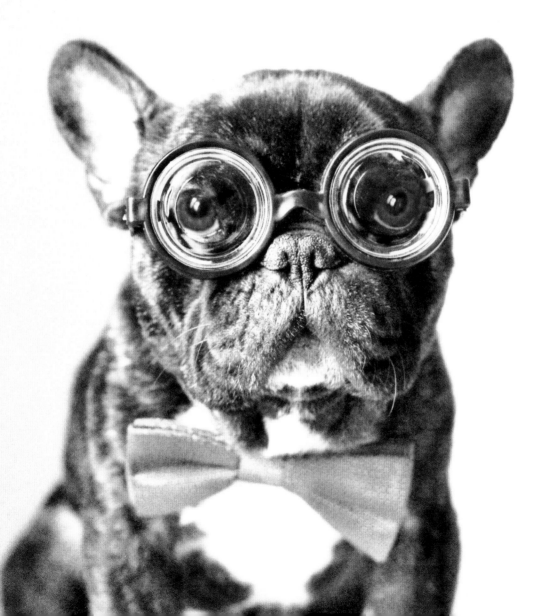

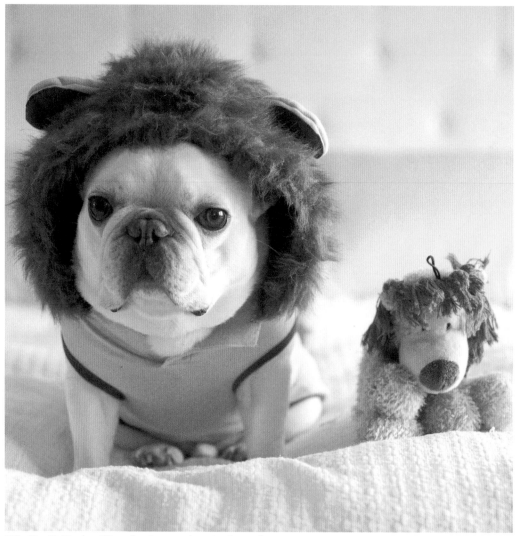

@**BarkleySirCharles** "One of us is gonna have to change."

@anniepaddington

@wallythewelshcorgi

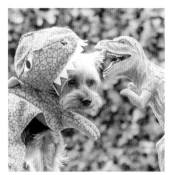

@pixiebugstudio

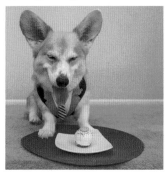

@wallythewelshcorgi

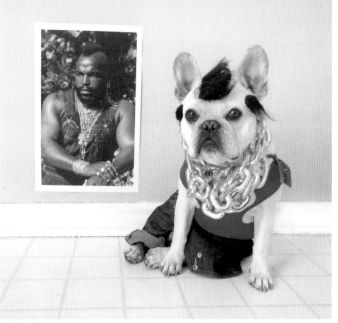

@dailydanger

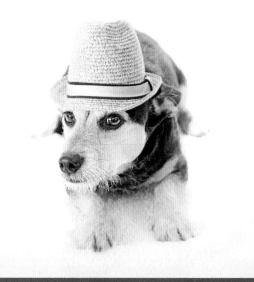

@PawsofOz

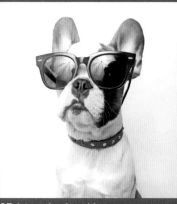

@Brixton_the_frenchie

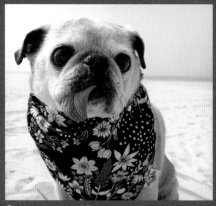

@roccopugzworld

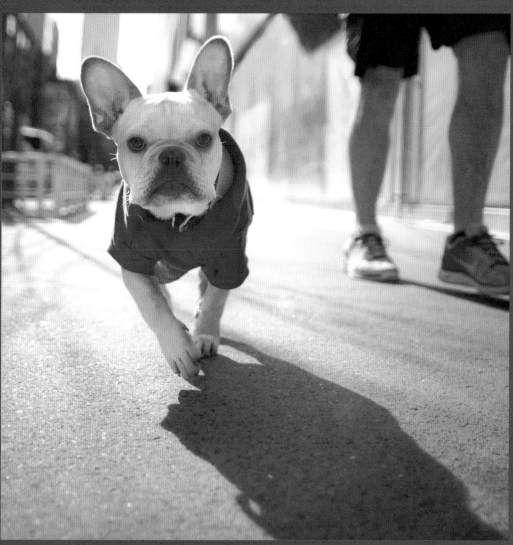

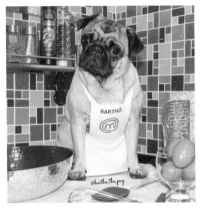

@bartho_the_pug

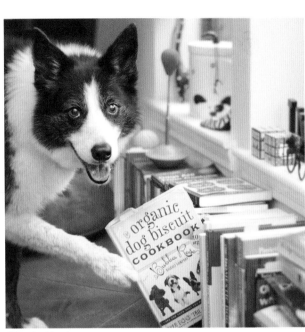

@BorderNerd

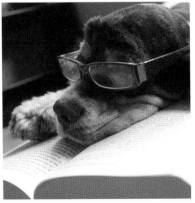

@MARIIKAC

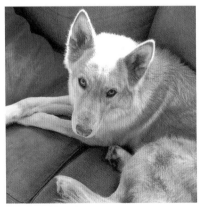

@kenai_Maya_Luna

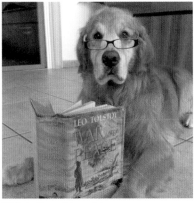

@blink_thegoldenretriever

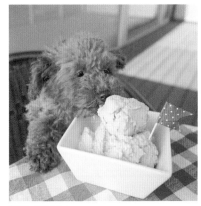

@LifeOfJinkee

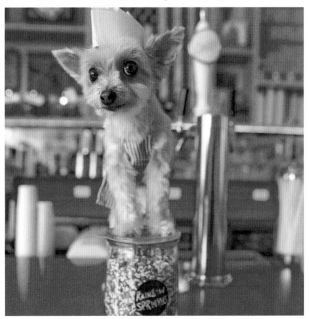

@ellabeanthedog

"Rainbow sprinkles, anyone?"

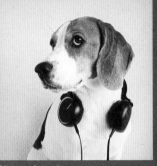

@jenny_beagle

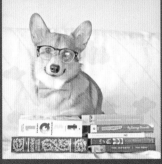

@littlecooperbear

@taikowaiko

@whitekatana

"Happy Take Your Dog to Work Day!"

@carterandtoby

"Eat. Sleep.
Instagram.
Repeat."

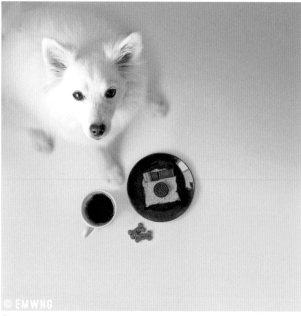

@emwng

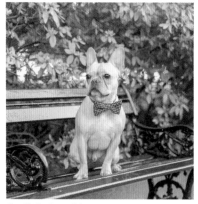

@sullythefrenchie

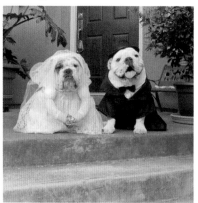

@bulldogcrew

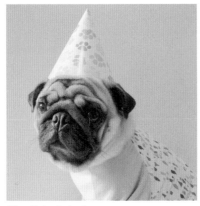

@Lostintechnicolor

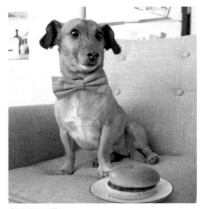

@blakewilbo

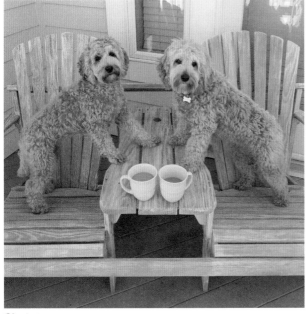

@igstagrams

@avathepommy

"Coffee with my best friend."

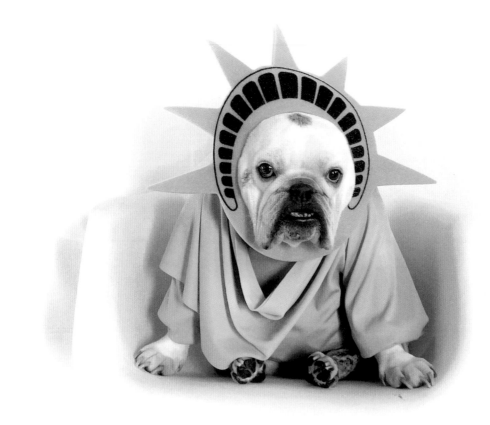

@bellatheaussie

@texthebc

@theadventuresofgus

@cheflisacooks

@Junior_the_copenhagen_lab

@manny_the_frenchie

@londonthecorgi

@brandonwoelfel

@happy_aussie

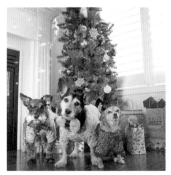

@pawsofoz

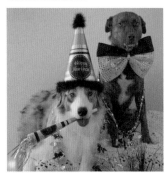

@aussie_and_a_mutt

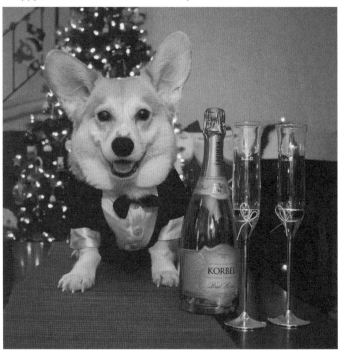

"Cheers."

@wallythewelshcorgi

@pixiebugstudio

@downsitplay

@wallythewelshcorgi

"Feliz Cinco de Mayo!

~ Señor Wally"

@trooperandmoe

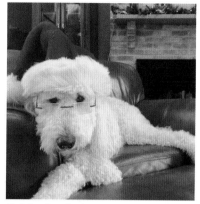

@chrissyharrington

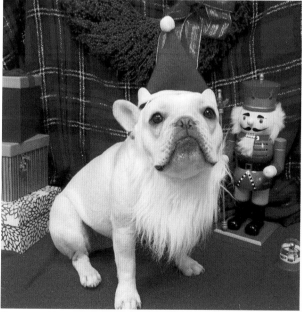

@potato.chip.and.martini

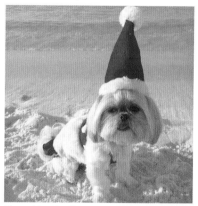

@sparklesthediva

"Spider-dog,
Spider-dog,
Does whatever
a Spider-dog
does."

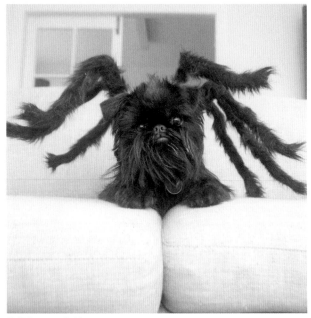

@digbyvanwinkle

@roccopugzworld

@teddylovesmeatloaf

@chanceytheaussie

@rileybeann

@pixiebugstudio

@downsitplay

@anh85

@bonjour_manoush

@johnnybotelho

@pinguthepom

@bjdjango12

"Matilde and Martin taking a sun bath."

@davideuribe

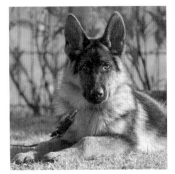
@oscar_gsd

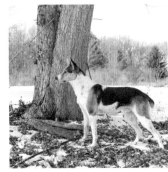
@muttnuggets

@aquacorg

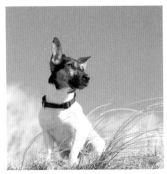
@cookie_jrt

@solidmfgco

"Every day
is National
Dog Day
around here."

@keithdesign

@bens_shots

@danidlm

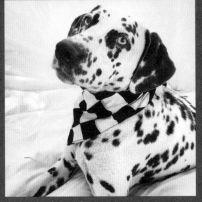

@bluethedalmatian

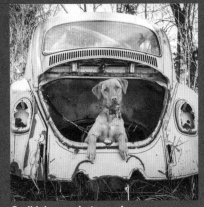

@erikjohnsonphotography

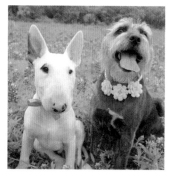
@Kat_1189

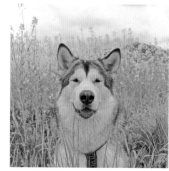
@alaskanakeela

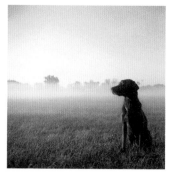
@chicago_bear

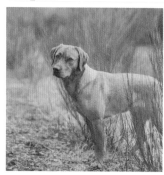
@loveoflabradors

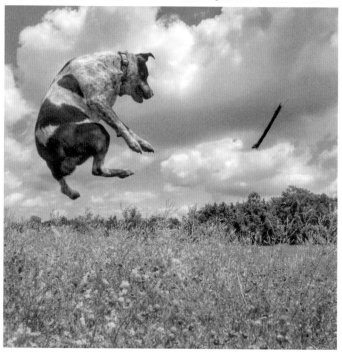

"Sweet, sweet Summertime!"

@run.love.dog

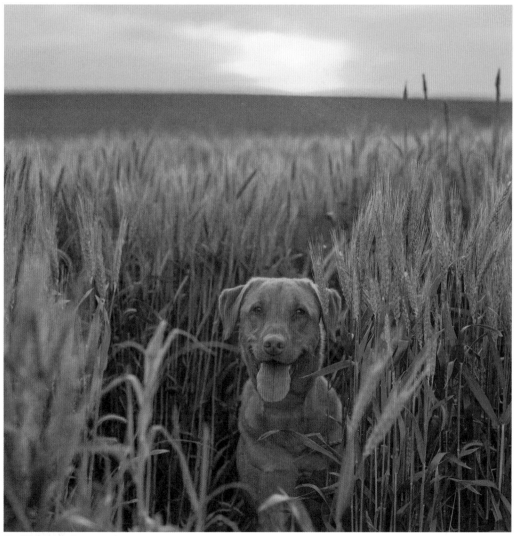

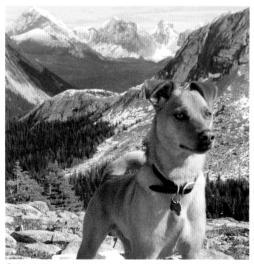

@domcarson

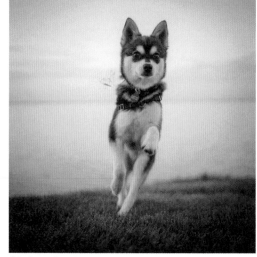

@buksnort

"Great day at my favorite watering hole!"

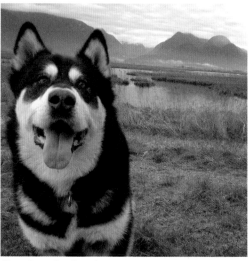

@westcoastmalamute

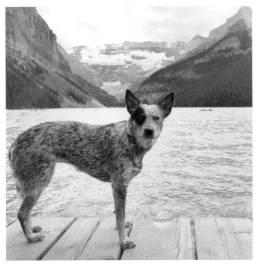

@lunablueheeler

@graywoof

@yoshithecavalier

"Yoshi loves exploring the Rocky Mountains; so many new smells and awesome walking trails."

@adventures_with_Riley

@Pigzilla

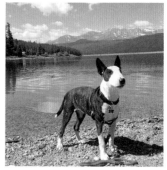

@rufiothebullterrier

@HeikosAdventures

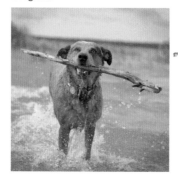

@toriasauras

"Nothin' better than a good stick and some swim time!"

@jdmarin

@3woofs4hoofs

@threelittlefrenchies

@GSD_kona

"Happy #tongueouttuesday."

@onlymydogandme

@jessica_caiazza

@scvitkovic1

@ellie_and_finnegan "This was our first warm day of the year!"

@_luna365

@abbey_and_zeus

@abbey_the_aussie

@viktorsimco

@_kaila_b_9

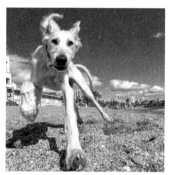
@pakvas74

@oscar_gsd

@labradorablepip

"Shiro, on his first forest trip!"

@Haku.Shiro

@TheMalcolmDog

@goldenlambo

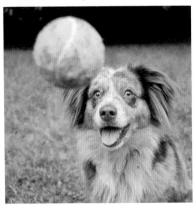

@Corgi_Aussie

"Rio, think fast!"

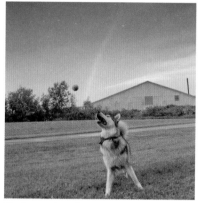

@eska_and_meka

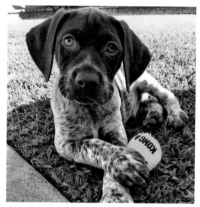

@tuckergsp

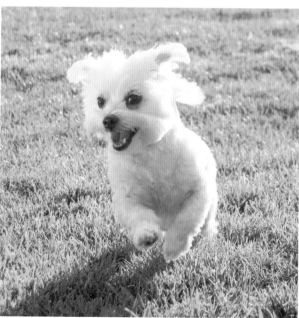

@kawaiilyla

@lifewithtoby

@shineonyoucraydiamond

@spyro_dog

@_kippp_

"The shelter didn't think I would get adopted because I was born blind in one eye. But I did because, well, look at me!"

@mercysdoorpetrescue

@super_rotti

@copperxbeagle

@iheartwallace

@oswin_the_ear

@kendramariephoto

@mercysdoorpetrescue

@bearpaw_dood

@maltimutt

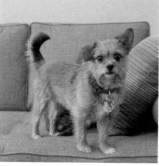

@Kobe.GSD

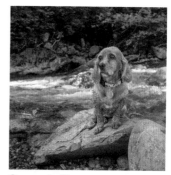

@mycaninelife

@lillypadpup

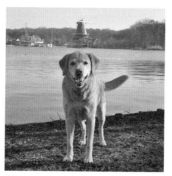

@labradorablepip

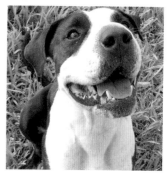

@gchscorpuschristi

@bokehdog

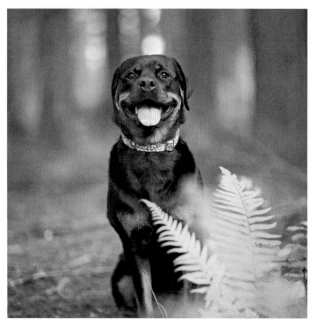

@graceytherottweiler

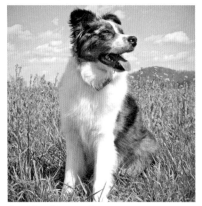

@agirlandheraussie

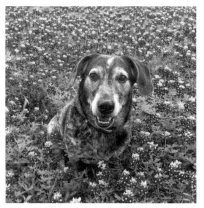

@rafa3lla

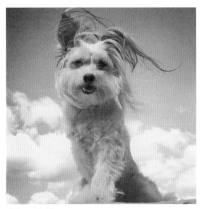

@Jeanie3legs

"This is Jeanie. She's an adopted rescue and a certified therapy dog."

@lisagarsson

@renata_tan

@badassbrooklyn

@levi.and.delilah

@_sarahfriedman

@brockob

"Give a pitbull your love and you'll never regret it!"

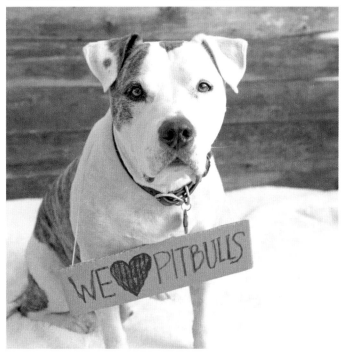
@iheartwallace

@leanncastellanos

@kenai_Maya_luna

@my.3.musketeers

@lykke_thecollie

"Sometimes you end up with awkward family photos."

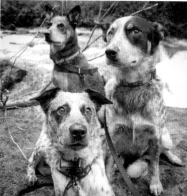

@dahliathedingo

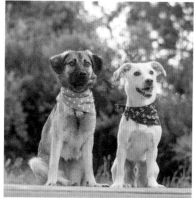

@sammys_doglife

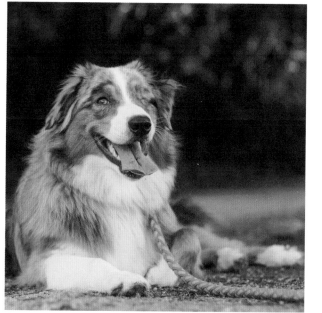

@splendidcyclops

@mydogarthur

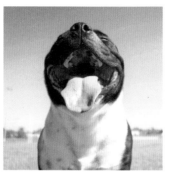

@anto.fda

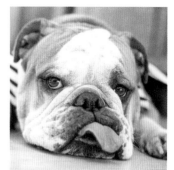

@rortiophotography

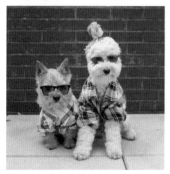

@thedappernapper

@kodathepuggle

"OMG IT'S THE
WEEKEND!"

@musingsofmia

"I give you, the evolution of dog."

@YourDogCharlie

@rileybeann

@thefugee

@**sillytalkswitheddie** "His favorite pastime is Netflix binge watching."

@8littlepaws

@lynzeyy

@maggiedoodlemccoy

@ch1di

@Corgi_Aussie

@soap_the_frenchie

"Dog happens."

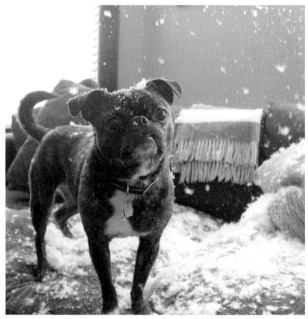

@dogsofinstagram

@noodlethedachshund

@thetrickdog

@_deeks_

@evys_mom

@roy.son

"Squirrel!"

@Nikko_bear

@hello.ellie

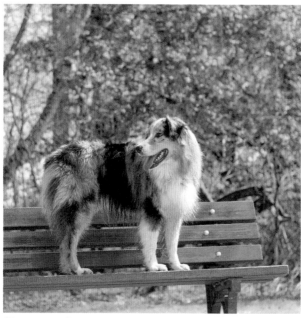

"Spring is such a beautiful season!"

@happy_aussie

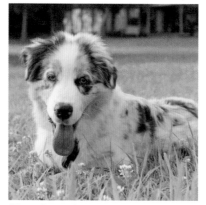

@beautheaussiex

@sallyefrank

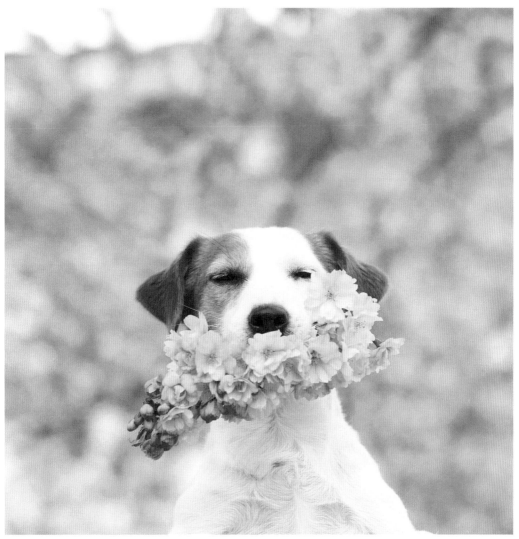

@enyahabel

@agrady4

@mdool090

@scottthetoller

@gchscorpuschristi

@thenewenglandshop

@trinketbaby

@_luna365

"What are these?"

@Fridolita

@agirlandheraussie

@spyro_dog

@duna_pdae

@evys_mom

@forresthedood

@lizzie.bear

@bluemerle

@barkingalltheway

@lillypadpup

@janeyc_

@lexiesheartbeat

@cookie_jrt

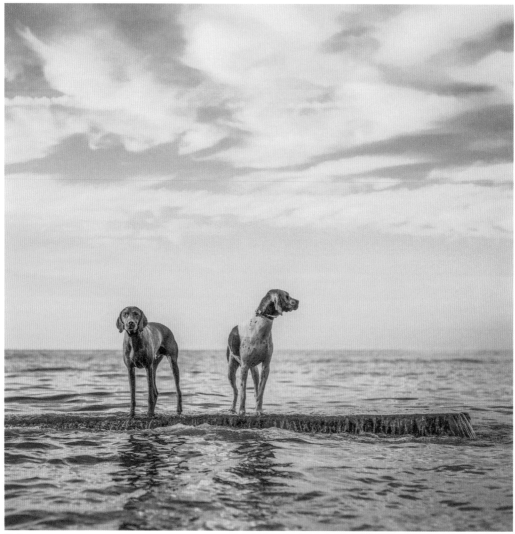

@clegreg

@chompersthecorgi

@sillytalkswitheddie

@little.sawyer

@ali.cliff

@forresthedood

@littleleiacorgi

@king.leonardo

@clari_calahari

@fred_says @cbauerphoto

@simonthejackchi

@kleinandfriends

@daphnetheadventuredog

@ngottliebphoto

@thesparkedlife

@cali.the.dog

@Corgi_Aussie

@SirBaxterFly

"Don't forget your sunscreen!"

@Corgi_Aussie

@millytheminiature "Milly planning her next adventure."

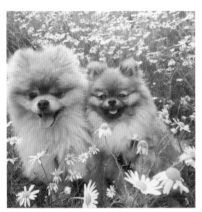

@Dominik_the_pomeranian

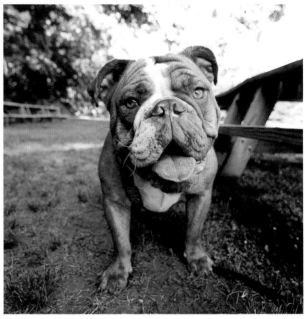

@piggyandigor

@emilefrey

@PixelPaws

@Joeyyjax

@ellabeanthedog

@ranger_and_bandit

@thepawsome3

"Must be summer."

@hermes.lion

@smalls.the.corgi

@Nickiboschphotography

@Joeyyjax

"You can't buy happiness, but you can buy ice cream and that's kind of the same thing."

@rileybeann

@lifewithtoby

@missmiau

@bennifla

@samoyedpuck

@2maez

@herbieandfern

@mrshenson_26

@Jennycarlsso

@perronella

@puggledogs

"My goal this school year is to become the teacher's pet. I'm pretty confident I've got that dialed in."

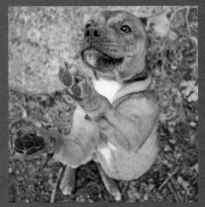

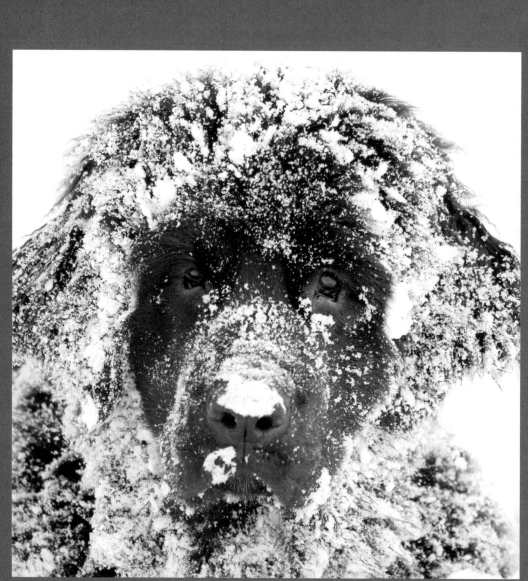

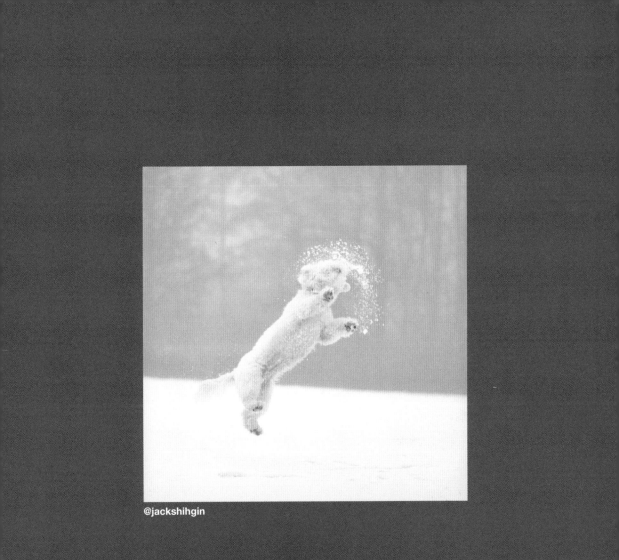
@jackshihgin

@emimitosis

@nadiarodman

@xobrogan

@murray_doodle

"The sky is
the limit."

@clari_calahari

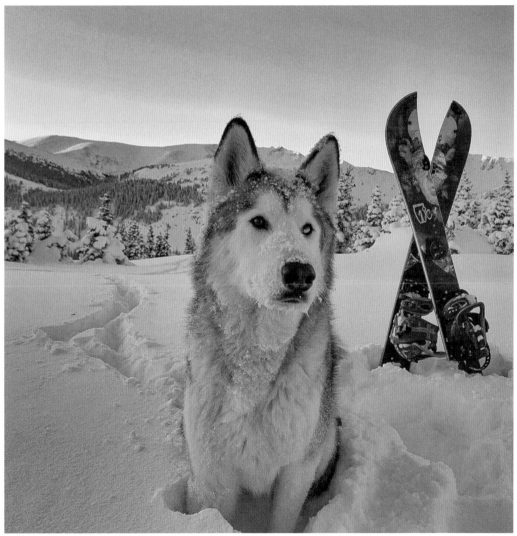

@loki_the_wolfdog "An early morning on the summit before the descent."

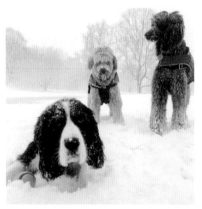

@brooklyndogtime

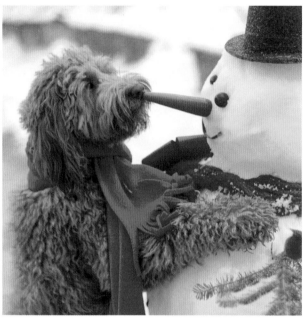

@oliverthegoldendoodle

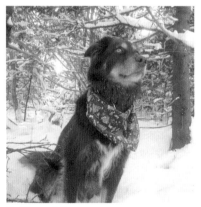

@ellie_and_finnegan

@lizzie.bear

@xobrogan

@brianch82

@yogi000008

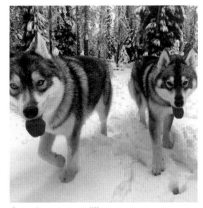

@carrie_mona_millie

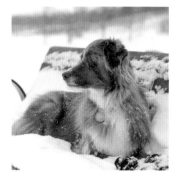

@me_and_my_aussies

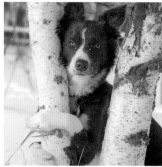

@evys_mom

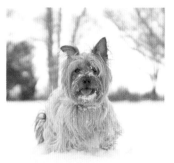

@thoughtfulnote

@toriasauras

"Our first
snowfall of
the season."

@rocky_the_naid

@kodathepuggle

@whiskey_theaussie

@olivialansingherrick

@evys_mom

@pawsandpaint

@brookepavel

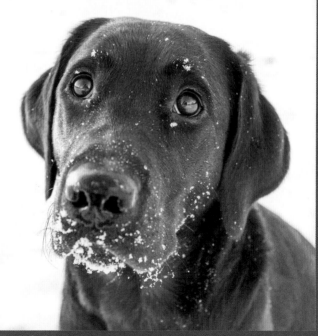

"It's Ursa's first winter, and she loves the snow!"

@pawsandpaint

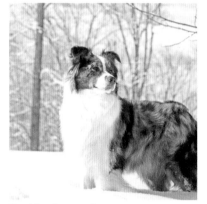

@agirlandheraussie

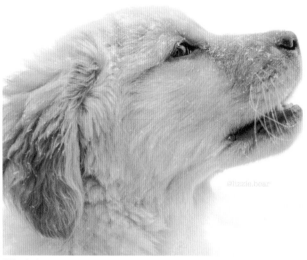

@lizzie.bear

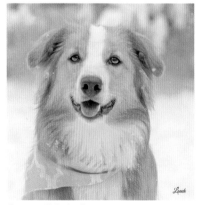

@myenglishshadow

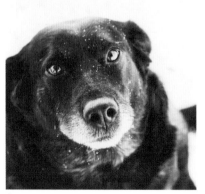

@sweetcara

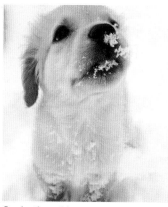

@nala_thegoldenpup

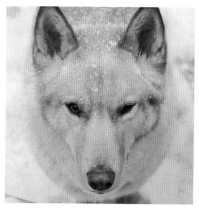

@kenai_Maya_luna

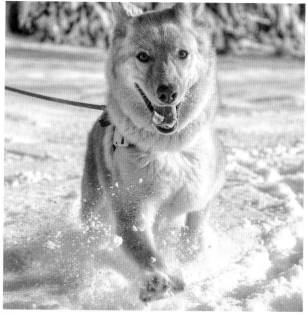

@kenai_Maya_luna

"Snow days are
the best."

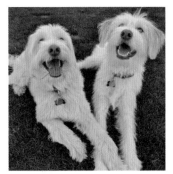

@bensonandlexi

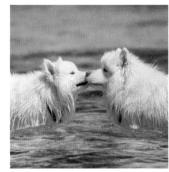

@thepawsome3

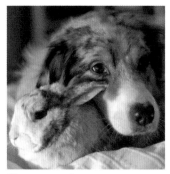

@happy_aussie

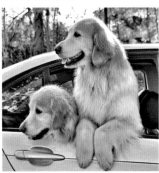

@kimmie_wimmie

"A good nap
requires a
great pillow."

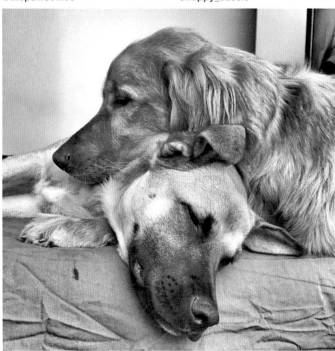

@paulesa

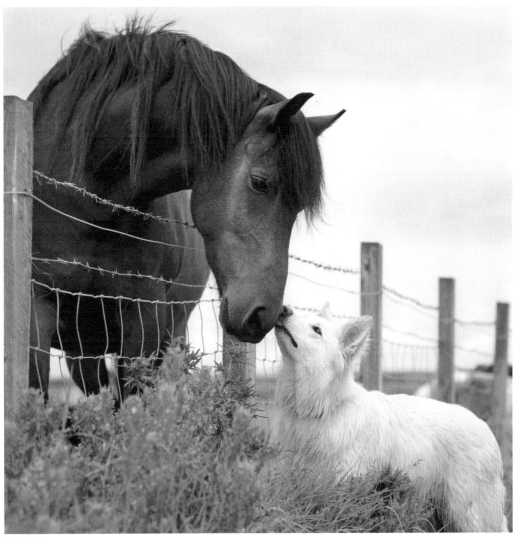

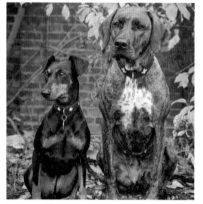

@nala_abbie

@thebarkhaus

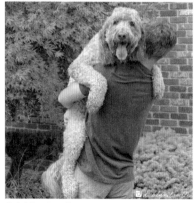

@dublyndoodle

"Eleanor teaches
us that sometimes
in life, all you need
is a hug!"

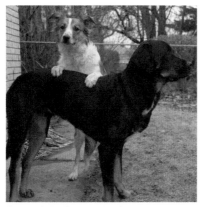

@LivingItDigital

@ranger_and_bandit

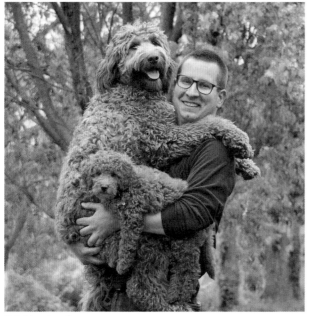

@dublyndoodle

@raylan_the_dog

@nalamendez

@alandawe

@pugs_in_the_city

@dexterandkhaleesi

@nelsonthegoldendoodle @hudsonthegoldendoodle
@samsonthedood

@crazyaboutspots

@kobeandrooney

@AussieFluff

@lovelablife

@thepawsome3

@_luna365

"Henry and his new little sister, Penny. They have quickly become best friends."

@henryandpenny

@saff_pstm

@cookie_cute

@martabjs_

@thetrio_22

@anhanha_

@marcharrismiller

@deanthebasset

@spotsthebulldog

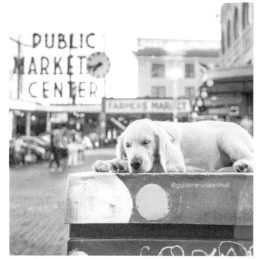

@goldens.unleashed

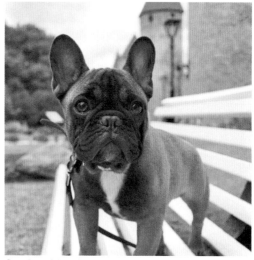

@mr.frenchbulldog

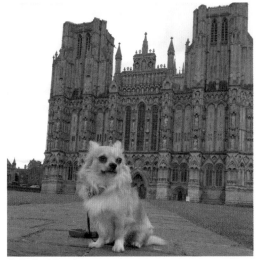

@gimli_chihuahua

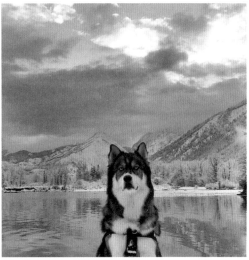

@Goldilocksandthewolf

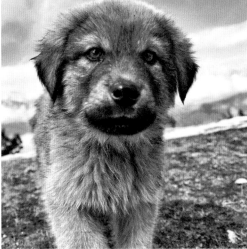

@outdoorswe

"Met this little furry friend during a trek in the Himalayas."

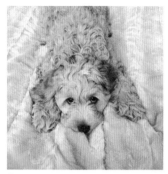

@erickashaw

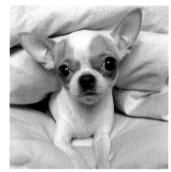

@thatcher_n_jackie_o

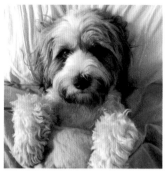

@adamthornton

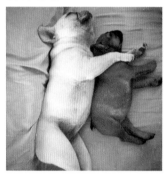

@basilhaydenontherocks

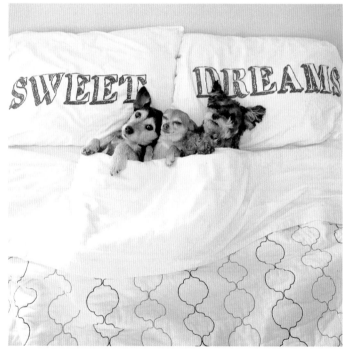

"The ruff life."

@pawsofoz

@thor_s

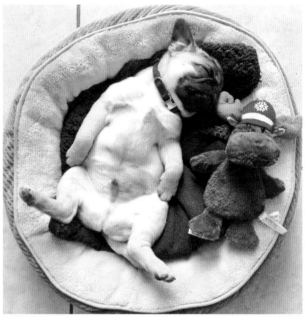

@bruno_gmz

@nixonthecorgi

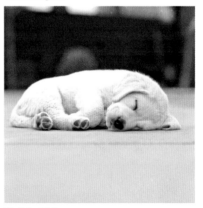

@pfotentick

@ungdee

@pinguthepom

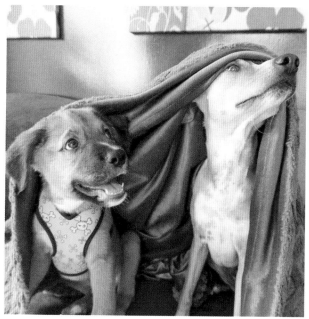

@simonthejackchi

"We woke up
like this."

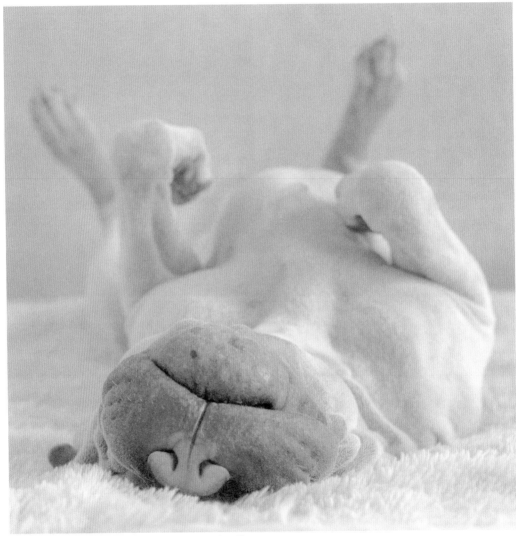

@anniepaddington "Paddington had a big weekend"

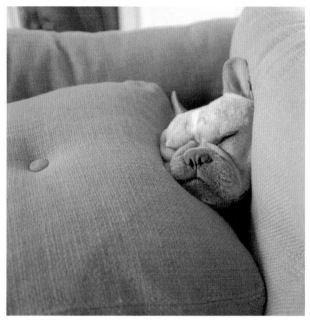

"Snuggling is the best kind of sleep."

@thefrenchpig

@pawsofoz

@willa_thepup

@aussieejack

@loveoflabradors

@Emmtann

@jax_thefrenchbully

@chef_the_bulldog

@thelifeof_hank

@sammys_doglife

@simonthejackchi

"Do you wanna cuddle?"

@pixel_the_frenchie

@dimiecalvin "Good night."

@E2Productions

@roofusandkilo

@blueheelerbeau

"A tired Heeler is a
happy Heeler."

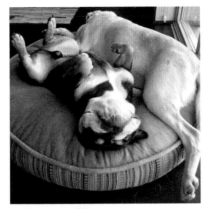

@chef_the_bulldog

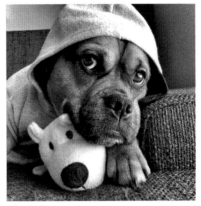

@kodathepuggle

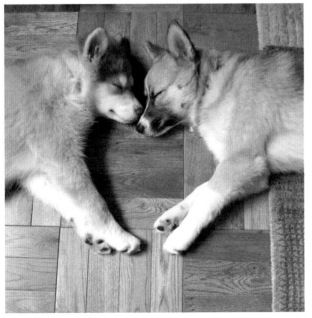

@pomsky_princesses

@herkythecavalier

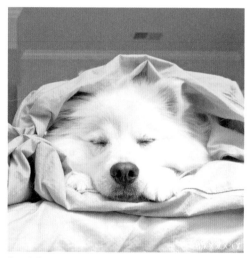

@mobibear "A pup in hibernation."